T0023889

It is rare that a single publication by an art historian can be said to have changed the world, but this is exactly what Linda Nochlin did with her 1971 text, 'Why Have There Been No Great Women Artists?' At that time, from my self-guided research (which resulted in *The Dinner Party*), I had already discovered that the art historical certainty about the paucity of great female artists in history was false. But for the profession, it was a revelation, one that produced generations of feminist art historians (both female and male) who began to excavate history and in so doing, initiated a revolution in the canon that is still ongoing.

Judy Chicago

Why have there been no great women artists?

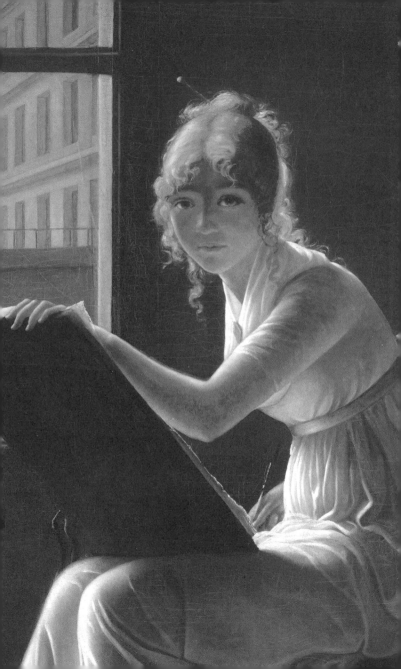

Linda Nochlin

Why have there been no great women artists?

Contents

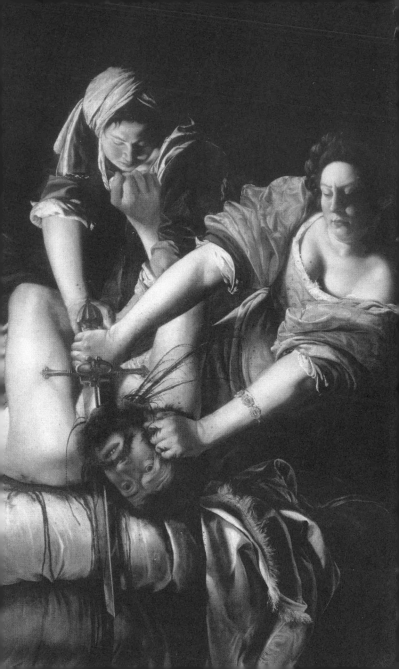

Introduction

Catherine Grant

Linda Nochlin's essay 'Why Have There Been No Great Women Artists?', first published in 1971, established the ground for feminist art history. It remains relevant today for its vivid critique of 'greatness' as an innate quality, as well as for exploring how women artists have managed to succeed against institutional exclusion and social inequalities. As a number of commentators have explored, the term 'woman artist' is as much of a historical construction as that of the 'great artist'.[1] The focus on artists who are women enabled a wider critique of the ideological underpinnings of art history that, at the time Nochlin was writing, often masked the grounds for assigning greatness, talent and success. As Nochlin put it, the supposedly neutral position of the scholar in most disciplines was 'in reality the white-male-position-accepted-as-natural'.[2] She then detailed the impact of this on artists 'who did not have the good fortune to be born white, preferably middle class, and, above all, male.'[3] Her conclusions and suggested lines of further enquiry remain open for further investigation today.

In the fifty years since its publication, Nochlin's essay has become a touchstone for feminist writers, artists and curators.

Many undergraduate courses in art and art history continue to set it as an entry point into discussions around structural inequality and the fantasies that still abound when thinking about creativity and greatness. The title 'Why Have There Been No Great Women Artists?' has permeated popular culture to the extent that it was emblazoned on T-shirts at a Dior fashion show in 2017, with beautifully bound copies of the essay distributed to the spectators. With many women artists now considered 'great', is it still necessary to engage with Nochlin's essay in detail? In this introduction, I will argue Nochlin's critical analysis exposes assumptions that are still hard to shake within art and art history. I will summarize her essay's key points, and contextualize them in relation to Nochlin's own opinion of this foundational work, drawing on the second essay published here, written in 2001, and ending with a consideration of what is needed for feminist art history today.

One of the key elements of Nochlin's 1971 essay is how she responds to the question 'Why Have There Been No Great Women Artists?' In the original version, published in the journal *ARTnews* as part of a special issue on 'Women's Liberation, Woman Artists and Art History,' an introductory line reads 'Implications of the Women's Lib movement for art history and for the contemporary art scene – or, silly questions deserve long answers'.[4] This line is not reproduced in the subsequent reprints of the text, but points to a crucial element of Nochlin's argument: the title is a 'silly question'. Within the essay she warns that the question is not to be taken at face value, but instead interrogates its assumptions.

This leads to her central argument that creativity is fostered through institutional and educational support, not a mysterious germ of genius or talent. To make her point, she asks the reader to reformulate the question in regards to another demographic: the aristocracy. She argues that like women, aristocrats have not historically become great artists because the demands and expectations of their social position have 'made total devotion to professional art production out of the question'.[5] She argues that 'art making, both in terms of the development of the art maker and in the nature and quality of the work of art itself, occur in a social situation', specifying a range of institutions and expectations including 'art academies, systems of patronage, mythologies of the divine creator, artist as he-man or social outcast.'[6] For women, then, she sets out (in one of the most quoted sections of the essay):

> The fault lies not in the stars, our hormones, our menstrual cycles, or our empty internal spaces, but in our institutions and our education – education understood to include everything that happens to us from the moment we enter this world of meaningful symbols, signs, and signals.[7]

After demolishing the fuzzy ground underpinning notions of 'greatness' (including a detailed exploration of how women were excluded from a foundational skill for artists from the Renaissance to the end of the nineteenth century: drawing from nude models), Nochlin moves on to explore how women artists *have* succeeded. Using the nineteenth-century painter Rosa Bonheur as a case study, she describes how Bonheur's

father was a 'impoverished drawing master', and that like many men (Nochlin cites Picasso), having an artist-father allowed for the blossoming of creativity that might later be attributed to a mysterious notion of genius. What she doesn't explore in detail is the presence of Rosa Bonheur's partner, the artist Nathalie Micas. Nochlin asserts that their relationship was most likely platonic, whereas now it is generally accepted that the two women lived as a married couple. Here Bonheur has an 'artist-wife' or an 'artist-sister' as well as an 'artist-father', pointing to a proto-queer-feminist community of at least two. By describing Bonheur's life, 'masculine' dress, and relationships, Nochlin indirectly points to the subsequent emergence of lesbian and queer feminist thinking around communities, sexuality and non-normative kinship structures that continues into the present, as well as her insight that individual men's support, particularly that of artist-fathers, has been crucial in the face of patriarchal exclusions.

In discussing successful women artists such as Bonheur, Nochlin concedes that they may not have been art superstars on the level with Michelangelo or Picasso, but nonetheless, carved out spaces for themselves across the centuries, ranging from the thirteenth-century sculptor Sabina von Steinbach through to twentieth-century artists including Käthe Kollwitz and Barbara Hepworth. In her later writing, and in subsequent critiques of her work, this notion of masculine, Western superstardom is itself qualified as specific to the post-World War Two period. Rozsika Parker and Griselda Pollock's important volume *Old Mistresses: Women, Art and Ideology*, from 1981, further argues that women artists

were present in writing and exhibitions *until* the twentieth century, when they were erased from histories of art from the rise of modernism onwards. As Pollock puts it, feminist art historians in the 1970s 'had to become archaeologists' to undo the 'structural sexism in the discipline of Art History itself.'[8]

In Nochlin's subsequent writing, and through curation of shows starting with 'Women Artists: 1550–1950' (with Ann Sutherland Harris) in 1976, she contributed to the huge project of re-imagining histories of art that do not exclude or belittle the work of women artists. In the original publication of 'Why Have There Been No Great Women Artists?' there are numerous illustrations that run alongside the text, ranging from a nun's collaborative medieval illumination from the tenth century to contemporary works by Agnes Martin and Louise Bourgeois. A full-page reproduction of Artemisia Gentileschi's *Judith Beheading Holofernes* (*c.*1614–20) is placed opposite the title page of the original magazine version of the essay, with the caption asserting that this painting could be '[a] banner for Women's Lib'. Whilst the captions are not explicitly attributed to Nochlin, they have the same conversational lightness that drives her profoundly serious argument. These illustrated artworks by women assert the richness of practices that have been excluded from histories of art, and claims their importance, whilst still holding on to the central argument that refutes the ideological basis for traditional art historical judgment. The complex interplay that Nochlin achieves in the essay is sometimes misunderstood as a call to create a canon of great women artists. This is not the case, but her essay does begin to provide her (women) readers with the tools to imagine what

it means to be a successful artist or write about women's art.

Thirty years later, in 2001, Nochlin explored how in the 1970s feminist art history had to be constructed: 'new materials had to be sought out, theoretical bases put in place, methodologies gradually developed.'[9] In her essay 'Why Have There Been No Great Women Artists? Thirty Years After' she argues that 'feminist art history is there to make trouble, to call into question, to ruffle feathers in patriarchal dovecotes.'[10] This trouble-making was done in 1971 by the incisive analysis of notions of 'genius' and 'greatness', but also through imagining the relevance of this trouble-making to the contemporary context of the Women's Liberation Movement. Even earlier than this, Nochlin had been concerned with thinking through the stakes of being marginalized, or 'othered', and what this might offer to radical forms of scholarship. In another of her pithy, often-quoted statements she says, 'Nothing, I think, is more interesting, more poignant, and more difficult to seize, than the intersection of the self and history.'[11] Written as part of an essay that recounts her intellectual formation, including her experiences of the Women's Liberation Movement, she describes how she came to reject a single approach when it came to her art historical work, and how she developed an 'ad hoc methodology' which drew on personal experience, political theory and social history, as well as traditional art historical methods such as iconography.[12] To describe this 'intersection between self and history' she recounts a trip to the UK in 1948, where, at age 17, she said she first understood herself as 'a Jew from Brooklyn.'[13] This sense of being marginalized in relation to dominant cultural structures, and

how it made her interrogate the 'white-male position-accepted -as natural', led to Nochlin's life-long interest in thinking about identity and its representation. Across the course of her incredibly rich career she explored many topics alongside her well-known focus on gender, including the representation of Jewish identity, ageing, 'Orientalism', motherhood, eroticism and class relations.

The range of topics that can be found in Nochlin's writing points to her intersectional feminist approach, one that is very much needed fifty years after the publication of her famous essay. Discussions that have taken place since the early 1970s around race, class, ethnicity and sexuality are still areas where more research is needed in relation to feminist politics and art history. Nochlin's 1971 title has been often repurposed, as in a recent essay by Eliza Steinbock which asks 'Why have there been no great trans* artists?'[14] Researchers such as Nochlin, Pollock and other pioneers of feminist art history describe going into the stores of galleries and museums to find works by women artists that had not been displayed for decades in the 1970s. This is paralleled in recent years with current research uncovering works by artists of colour, such as the database created by the Black Artists and Modernism project through an audit of 'artworks by black artists in public collections' in the UK.[15] A survey of recent publications on feminist art history shows a range of global and transnational perspectives, although this is far from established. What is in place, however, is a strong community of feminist art historians and artists, who are building on the legacy of the critiques of art history begun in the 1970s.

It is with this focus on feminist community that I want to end. Nochlin's two essays reprinted here both insist on the importance of the communities that her writing has emerged from. In addition, in 'Memoirs of an Ad Hoc Art Historian,' she recalled in detail the first seminar on women and art that she taught at Vassar College in 1969, and how it provided much of the groundwork for her 1971 essay. She included herself when she described the undergraduates as 'a committed group of proto-feminist researchers', and how they were 'both inventors and explorers: inventors of hypotheses and concepts, navigating the vast sea of undiscovered bibliographical material, the underground rivers and streams of women's art and the representations of women.'[16] In her 2001 essay reprinted here, she continues to pay tribute to the community of scholars that make up feminist art history, refusing to be positioned as a figurehead, and instead confirming that 'We have – as a community, working together – changed the discourse and the production of our field.' She also warns against masculine heroics which she sees returning in art, politics and culture – returns which are still present today.[17] In the face of this, for readers fifty years on, Nochlin's description of the group of proto-feminist researchers is still important. For all of us committed to the ongoing, varied, intersectional and evolving project of writing feminist art history and making feminist art, we need to continue to see ourselves as 'inventors and explorers', to continue to ask questions and embrace causing trouble.

Acknowledgments

Thanks to Sam Bibby, Althea Greenan, Hilary Robinson and Lynora Williams (Director of the Betty Boyd Dettre Library and Research Center, National Museum of Women in the Arts, Washington DC), for help finding crucial resources and speaking to me about Nochlin's generous feminist legacies to art history.

C.G.

Notes

1 See Carol Armstrong and Catherine de Zegher eds., *Women Artists at the Millennium*, Cambridge, Mass.: MIT Press, 2006.

2 Linda Nochlin, 'Why Have There Been No Great Women Artists?', 1971, in *Women, Art and Power and Other Essays*, Boulder, Colorado: Westview 1988, p. 145. Unless noted otherwise, all subsequent quotations are from this reprint.

3 Nochlin, *Women, Art and Power*, 1988, p. 150.

4 Linda Nochlin, 'Why Have There Been No Great Women Artists?', *ARTnews*, January 1971, p. 23.

5 Nochlin, *Women, Art and Power*, 1988, p. 157.

6 Nochlin, *Women, Art and Power*, 1988, p. 158.

7 Nochlin, *Women, Art and Power*, 1988, p. 150.

8 Griselda Pollock, 'A Lonely Preface,' in Rozsika Parker and Griselda Pollock, *Old Mistresses: Women, Art and Ideology*, London: I.B.Tauris, 1981, 2nd edition 2013, p. xxiii, p. xvii.

9 Linda Nochlin, 'Why Have There Been No Great Women Artists? Thirty Years After,' in *Women Artists at the Millennium*, 2006, p. 29.

10 Nochlin, *Women Artists at the Millennium*, 2006, p. 30.

11 Linda Nochlin, Introduction. Memoirs of An Ad Hoc Art Historian', in *Representing Women*, New York: Thames & Hudson, 1999, p. 33.

12 Nochlin, *Representing Women*, 1999, pp. 10–11.

13 Nochlin, *Representing Women*, 1999, p. 9.

14 Steinbock, Eliza, 'Collecting Creative Trans storot Trans* Portraiture History, from Snapshots to Sculpture,' in Hilary Robinson and Maria Elena Buszek eds., *A Companion to Feminist Art*, Hoboken, New Jersey: Wiley Blackwell, 2019.

15 'BAM National Collections Audit,' led by Dr Anjalie Dalal-Clayton as part of the Black Artists and Modernism project (2015–2018), <http://www.blackartistsmodernism.co.uk/black-artists-in-public collections/>(accessed 22 April 2020).

16 Nochlin, *Representing Women*, 1999, p. 19.

17 Mignon Nixon elaborates on this in her tribute essay,'Women, Art and Power After Linda Nochlin', *October*, 163, March 2019, pp. 131–132.

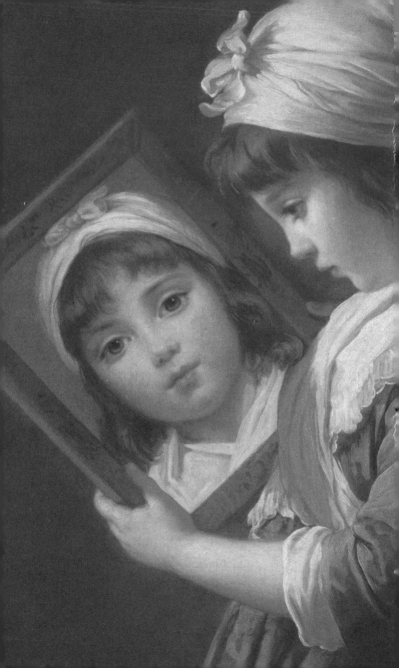

Why Have There Been Been No Great Women Artists?

ARTnews, January 1971

While the recent upsurge of feminist activity in this country has indeed been a liberating one, its force has been chiefly emotional—personal, psychological and subjective-centered, like the other radical movements to which it is related, on the present and its immediate needs, rather than on historical analysis of the basic intellectual issues which the feminist attack on the status quo automatically raises.[1] Like any revolution, however, the feminist one ultimately must come to grips with the intellectual and ideological basis of the various intellectual or scholarly disciplines—history, philosophy, sociology, psychology, etc.—in the same way that it questions the ideologies of present social institutions. If, as John Stuart Mill suggested, we tend to accept whatever *is* as natural, this is just as true in the realm of academic investigation as it is in our social arrangements. In the former, too, "natural" assumptions must be questioned and the mythic basis of much so-called "fact" brought to light. And it is here that the very

position of woman as an acknowledged outsider, the maverick "she" instead of the presumably neutral "one"—in reality the white-male-position-accepted-as-natural, or the hidden "he" as the subject of all scholarly predicates—is a decided advantage, rather than merely a hindrance or a subjective distortion.

In the field of art history, the white Western male viewpoint, unconsciously accepted as *the* viewpoint of the art historian, may—and does—prove to be inadequate, not merely on moral and ethical grounds, or because it is elitist, but on purely intellectual ones. In revealing the failure of much academic art history, and a great deal of history in general, to take account of the unacknowledged value system, the very *presence* of an intruding subject in historical investigation, the feminist critique at the same time lays bare its conceptual smugness, its meta-historical naïveté. At a moment when all disciplines are becoming more self-conscious, more aware of the nature of their presuppositions as exhibited in the very languages and structures of the various fields of scholarship, such uncritical acceptance of "what is" as "natural" may be intellectually fatal. Just as Mill saw male domination as one of a long series of social injustices that had to be overcome if a truly just social order were to be created, so we may see the unstated domination of white male subjectivity as one in a series of intellectual distortions which must be corrected in order to achieve a more adequate and accurate view of historical situations.

It is the engaged feminist intellect (like John Stuart Mill's) that can pierce through the cultural–ideological limitations of the time and its specific "professionalism" to reveal biases

and inadequacies not merely in dealing with the question of women, but in the very way of formulating the crucial questions of the discipline as a whole. Thus, the so-called woman question, far from being a minor, peripheral and laughably provincial sub-issue grafted onto a serious, established discipline, can become a catalyst, an intellectual instrument, probing basic and "natural" assumptions, providing a paradigm for other kinds of internal questioning, and in turn providing links with paradigms established by radical approaches in other fields. Even a simple question like "Why have there been no great women artists?" can, if answered adequately, create a sort of chain reaction, expanding not merely to encompass the accepted assumptions of the single field, but outward to embrace history and the social sciences, or even psychology and literature, and thereby, from the outset, to challenge the assumption that the traditional divisions of intellectual inquiry are still adequate to deal with the meaningful questions of our time, rather than the merely convenient or self-generated ones.

Let us, for example, examine the implications of that perennial question (one can, of course, substitute almost any field of human endeavor, with appropriate changes in phrasing): "Well, if women really *are* equal to men, why have there never been any great women artists (or composers, or mathematicians, or philosophers, or so few of the same)?"

"Why have there been no great women artists?" The question tolls reproachfully in the background of most discussions of the so-called woman problem. But like so many other so-called questions involved in the feminist "controversy," it falsifies the nature of the issue at the same time that it

insidiously supplies its own answer: "There are no great women artists because women are incapable of greatness."

The assumptions behind such a question are varied in range and sophistication, running anywhere from "scientifically proven" demonstrations of the inability of human beings with wombs rather than penises to create anything significant, to relatively open-minded wonderment that women, despite so many years of near-equality—and after all, a lot of men have had their disadvantages too—have still not achieved anything of exceptional significance in the visual arts.

The feminist's first reaction is to swallow the bait, hook, line and sinker, and to attempt to answer the question as it is put: i.e., to dig up examples of worthy or insufficiently appreciated women artists throughout history; to rehabilitate rather modest, if interesting and productive careers; to "re-discover" forgotten flower-painters or David-followers and make out a case for them; to demonstrate that Berthe Morisot was really less dependent upon Manet than one had been led to think—in other words, to engage in the normal activity of the specialist scholar who makes a case for the importance of his very own neglected or minor master. Such attempts, whether undertaken from a feminist point of view, like the ambitious article on women artists which appeared in the 1858 *Westminster Review*,[2] or more recent scholarly studies on such artists as Angelica Kauffmann and Artemisia Gentileschi,[3] are certainly worth the effort, both in adding to our knowledge of women's achievement and of art history generally. But they do nothing to question the assumptions lying behind the question "Why have there been no great

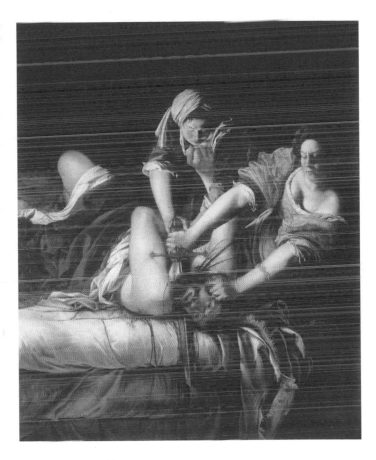

Artemisia Gentileschi, *Judith
Slaying Holofernes*, c.1614–20.

Oil on canvas, 78⅜ × 63⅞ in.
(199 × 162 cm)

women artists?" On the contrary, by attempting to answer it, they tacitly reinforce its negative implications.

Another attempt to answer the question involves shifting the ground slightly and asserting, as some contemporary feminists do, that there is a different kind of "greatness" for women's art than for men's, thereby postulating the existence of a distinctive and recognizable feminine style, different both in its formal and its expressive qualities and based on the special character of women's situation and experience.

This, on the surface of it, seems reasonable enough: in general, women's experience and situation in society, and hence as artists, is different from men's, and certainly the art produced by a group of consciously united and purposefully articulate women intent on bodying forth a group consciousness of feminine experience might indeed be stylistically identifiable as feminist, if not feminine, art. Unfortunately, though this remains within the realm of possibility it has so far not occurred. While the members of the Danube School, the followers of Caravaggio, the painters gathered around Gauguin at Pont-Aven, the Blue Rider, or the Cubists may be recognized by certain clearly defined stylistic or expressive qualities, no such common qualities of "femininity" would seem to link the styles of women artists generally, any more than such qualities can be said to link women writers, a case brilliantly argued, against the most devastating, and mutually contradictory, masculine critical clichés, by Mary Ellmann in her *Thinking about Women*.[4] No subtle essence of femininity would seem to link the work of Artemisia Gentileschi, Mme. Vigée Le

Brun, Angelica Kauffmann, Rosa Bonheur, Berthe Morisot, Suzanne Valadon, Käthe Kollwitz, Barbara Hepworth, Georgia O'Keeffe, Sophie Taeuber-Arp, Helen Frankenthaler, Bridget Riley, Lee Bontecou or Louise Nevelson, any more than that of Sappho, Marie de France, Jane Austen, Emily Brontë, George Sand, George Eliot, Virginia Woolf, Gertrude Stein, Anaïs Nin, Emily Dickinson, Sylvia Plath and Susan Sontag. In every instance, women artists and writers would seem to be closer to other artists and writers of their own period and outlook than they are to each other.

Women artists are more inward-looking, more delicate and nuanced in their treatment of their medium, it may be asserted. But which of the women artists cited above is more inward-turning than Redon, more subtle and nuanced in the handling of pigment than Corot? Is Fragonard more or less feminine than Mme. Vigée Le Brun? Or is it not more a question of the whole Rococo style of 18th-century France being "feminine," if judged in terms of a two-valued scale of "masculinity" vs "femininity"? Certainly, though, if daintiness, delicacy and preciousness are to be counted as earmarks of a feminine style, there is nothing fragile about Rosa Bonheur's *Horse Fair* [p. 77], nor dainty and introverted about Helen Frankenthaler's giant canvases. If women have turned to scenes of domestic life, or of children, so did Jan Steen, Chardin and the Impressionists—Renoir and Monet as well as Morisot and Cassatt. In any case, the mere choice of a certain realm of subject matter, or the restriction to certain subjects, is not to be equated with a style, much less with some sort of quintessentially feminine style.

The problem lies not so much with the feminists' concept of what femininity is, but rather with their misconception—shared with the public at large—of what art is: with the naïve idea that art is the direct, personal expression of individual emotional experience, a translation of personal life into visual terms. Art is almost never that, great art never is. The making of art involves a self-consistent language of form, more or less dependent upon, or free from, given temporally-defined conventions, schemata or systems of notation, which have to be learned or worked out, either through teaching, apprenticeship or a long period of individual experimentation. The language of art is, more materially, embodied in paint and line on canvas or paper, in stone or clay or plastic or metal—it is neither a sob-story nor a confidential whisper.

The fact of the matter is that there have been no supremely great women artists, as far as we know, although there have been many interesting and very good ones who remain insufficiently investigated or appreciated; nor have there been any great Lithuanian jazz pianists, nor Eskimo tennis players, no matter how much we might wish there had been. That this should be the case is regrettable, but no amount of manipulating the historical or critical evidence will alter the situation; nor will accusations of male-chauvinist distortion of history. The fact, dear sisters, is that there *are* no women equivalents for Michelangelo or Rembrandt, Delacroix or Cézanne, Picasso or Matisse, or even, in very recent times, for de Kooning or Warhol, any more than there are Black American equivalents for the same. If there actually were large numbers of "hidden" great women artists, or if there really

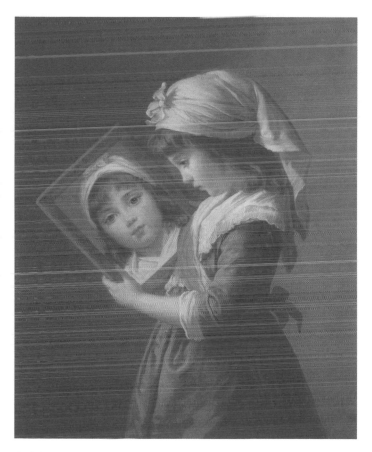

Elisabeth Vigée-Lebrun, *Julie Le Brun (1780–1819) Looking in a Mirror*, 1787.
Oil on canvas, 28¾ × 23⅛ in. (73 × 59.4 cm)

should be different standards for women's art as opposed to men's—and one can't have it both ways—then what are the feminists fighting for? If women have in fact achieved the same status as men in the arts, then the status quo is fine as it is.

But in actuality, as we all know, things as they are and as they have been, in the arts as in a hundred other areas, are stultifying, oppressive and discouraging to all those, women among them, who did not have the good fortune to be born white, preferably middle class and, above all, male. The fault, dear brothers, lies not in our stars, our hormones, our menstrual cycles or our empty internal spaces, but in our institutions and our education—education understood to include everything that happens to us from the moment we enter this world of meaningful symbols, signs and signals. The miracle is, in fact, that given the overwhelming odds against women, or blacks, that so many of both have managed to achieve so much sheer excellence, in those bailiwicks of white masculine prerogative like science, politics or the arts.

It is when one really starts thinking about the implications of "Why have there been no great women artists?" that one begins to realize to what extent our consciousness of how things are in the world has been conditioned—and often falsified—by the way the most important questions are posed. We tend to take it for granted that there really is an East Asian Problem, a Poverty Problem, a Black Problem—and a Woman Problem. But first we must ask ourselves who is formulating these "questions," and then, what purposes such formulations may serve. (We may, of course, refresh our memories with the connotations of the Nazi's "Jewish Problem.") Indeed, in

our time of instant communication, "problems" are rapidly formulated to rationalize the bad conscience of those with power: thus the problem posed by Americans in Vietnam and Cambodia is referred to by Americans as "the East Asian Problem," whereas East Asians may view it, more realistically, as "the American Problem"; the so-called Poverty Problem might more directly be viewed as the "Wealth Problem" by denizens of urban ghettos or rural wastelands; the same irony twists the White Problem into its opposite: a Black Problem; and the same inverse logic turns up in the formulation of our own present state of affairs as the "Woman Problem."

Now the "Woman Problem," like all human problems, so-called (and the very idea of calling anything to do with human beings a "problem" is, of course, a fairly recent one) is not amenable to "solution" at all, since what human problems involve is re-interpretation of the nature of the situation, or a radical alteration of stance or program *on the part of the "problems" themselves*. Thus women and their situation in the arts, as in other realms of endeavor, are not a "problem" to be viewed through the eyes of the dominant male power elite. Instead, *women* must conceive of themselves as potentially, if not actually, equal subjects, and must be willing to look the facts of their situation full in the face, without self-pity, or cop-outs; at the same time they must view their situation with that high degree of emotional and intellectual commitment necessary to create a world in which equal achievement will be not only made possible but actively encouraged by social institutions.

It is certainly not realistic to hope that a majority of men, in the arts, or in any other field, will soon see the light and find

that it is in their own self-interest to grant complete equality to women, as some feminists optimistically assert, or to maintain that men themselves will soon realize that they are diminished by denying themselves access to traditionally "feminine" realms and emotional reactions. After all, there are few areas that are really "denied" to men, if the level of operations demanded be transcendent, responsible or rewarding enough: men who have a need for "feminine" involvement with babies or children gain status as pediatricians or child psychologists, with a nurse (female) to do the more routine work; those who feel the urge for kitchen creativity may gain fame as master chefs; and, of course, men who yearn to fulfill themselves through what are often termed "feminine" artistic interests can find themselves as painters or sculptors, rather than as volunteer museum aides or part time ceramists, as their female counterparts so often end up doing; as far as scholarship is concerned, how many men would be willing to change their jobs as teachers and researchers for those of unpaid, part-time research assistants and typists as well as full-time nannies and domestic workers?

Those who have privileges inevitably hold on to them, and hold tight, no matter how marginal the advantage involved, until compelled to bow to superior power of one sort or another.

Thus the question of women's equality—in art as in any other realm—devolves not upon the relative benevolence or ill-will of individual men, nor the self-confidence or abjectness of individual women, but rather on the very nature of our institutional structures themselves and the view of reality which they impose on the human beings who are part of them. As John Stuart Mill pointed out more than a century ago: "Everything

which is usual appears natural. The subjection of women to men being a universal custom, any departure from it quite naturally appears unnatural."[5] Most men, despite lip-service to equality, are reluctant to give up this "natural" order of things in which their advantages are so great; for women, the case is further complicated by the fact that, as Mill astutely pointed out, unlike other oppressed groups or castes, men demand of her not only submission but unqualified affection as well; thus women are often weakened by the internalized demands of the male dominated society itself, as well as by a plethora of material goods and comforts: the middle-class woman has a great deal more to lose than her chains.

The question "Why have there been no great women artists?" is simply the top tenth of an iceberg of misinterpretation and misconception: beneath lies a vast dark bulk of shaky *idées reçues* about the nature of art and its situational concomitants, about the nature of human abilities in general and of human excellence in particular, and the role that the social order plays in all of this. While the "woman problem" as such may be a pseudo-issue, the misconceptions involved in the question "Why have there been no great women artists?" points to major areas of intellectual obfuscation beyond the specific political and ideological issues involved in the subjection of women. Basic to the question are many naïve, distorted, uncritical assumptions about the making of art in general, as well as the making of great art. These assumptions, conscious or unconscious, link together such unlikely superstars as Michelangelo and Van Gogh, Raphael and Jackson Pollock under the rubric of "Great"—an honorific

attested to by the number of scholarly monographs devoted to the artist in question—and the Great Artist is, of course, conceived of as one who has "Genius"; Genius, in turn, is thought of as an atemporal and mysterious power somehow embedded in the person of the Great Artist.[6] Such ideas are related to unquestioned, often unconscious, meta-historical premises that make Hippolyte Taine's race-milieu-moment formulation of the dimensions of historical thought seem a model of sophistication. But these assumptions are intrinsic to a great deal of art-historical writing. It is no accident that the crucial question of the conditions *generally* productive of great art has so rarely been investigated, or that attempts to investigate such general problems have, until fairly recently, been dismissed as unscholarly, too broad, or the province of some other discipline, like sociology. To encourage a dispassionate, impersonal, sociological and institutionally oriented approach would reveal the entire romantic, elitist, individual-glorifying and monograph-producing substructure upon which the profession of art history is based, and which has only recently been called into question by a group of younger dissidents.

Underlying the question about woman as artist, then, we find the myth of the Great Artist—subject of a hundred monographs, unique, godlike—bearing within his person since birth a mysterious essence, rather like the golden nugget in Mrs. Grass' chicken soup, called Genius or Talent, which, like murder, must always out, no matter how unlikely or unpromising the circumstances.

The magical aura surrounding the representational arts and their creators has, of course, given birth to myths since

the earliest times. Interestingly enough, the same magical abilities attributed by Pliny to the Greek sculptor Lysippos in antiquity—the mysterious inner call in early youth, the lack of any teacher but Nature herself—is repeated as late as the 19th century by Max Buchon in his biography of Courbet. The supernatural powers of the artist as imitator, his control of strong, possibly dangerous powers, have functioned historically to set him off from others as a godlike creator, one who creates Being out of nothing. The fairy tale of the Boy Wonder, discovered by an older artist or discerning patron, usually in the guise of a lowly shepherd boy, has been a stock-in-trade of artistic mythology ever since Vasari immortalized the young Giotto, discovered by the great Cimabue while the lad was guarding his flocks, drawing sheep on a stone; Cimabue, overcome with admiration by the realism of the drawing, immediately invited the humble youth to be his pupil.[7] Through some mysterious coincidence, later artists including Beccafumi, Andrea Sansovino, Andrea del Castagno, Mantegna, Zurbarán and Goya were all discovered in similar pastoral circumstances. Even when the young Great Artist was not fortunate enough to come equipped with a flock of sheep, his talent always seems to have manifested itself very early, and independent of any external encouragement: Filippo Lippi and Poussin, Courbet and Monet are all reported to have drawn caricatures in the margins of their school-books instead of studying the required subjects—we never, of course, hear about the youths who neglected their studies and scribbled in the margins of their notebooks without ever becoming anything more elevated than department-store clerks or shoe salesmen.

The great Michelangelo himself, according to his biographer and pupil, Vasari, did more drawing than studying as a child. So pronounced was his talent, reports Vasari, that when his master, Ghirlandaio, absented himself momentarily from his work in Santa Maria Novella, and the young art student took the opportunity to draw "the scaffolding, trestles, pots of paint, brushes and the apprentices at their tasks" in this brief absence, he did it so skillfully that upon his return the master exclaimed: "This boy knows more than I do."

As is so often the case, such stories, which probably have some truth in them, tend both to reflect and perpetuate the attitudes they subsume. Despite any basis in fact of these myths about the early manifestations of Genius, the tenor of the tales is misleading. It is no doubt true, for example, that the young Picasso passed all the examinations for entrance to the Barcelona, and later to the Madrid, Academy of Art at the age of fifteen in but a single day, a feat of such difficulty that most candidates required a month of preparation. But one would like to find out more about similar precocious qualifiers for art academies who then went on to achieve nothing but mediocrity or failure—in whom, of course, art historians are uninterested—or to study in greater detail the role played by Picasso's art-professor father in the pictorial precocity of his son. What if Picasso had been born a girl? Would Señor Ruiz have paid as much attention or stimulated as much ambition for achievement in a little Pablita?

What is stressed in all these stories is the apparently miraculous, non-determined and a-social nature of artistic achievement; this semi-religious conception of the artist's role

is elevated to hagiography in the 19th century, when both art historians, critics and, not least, some of the artists themselves tended to elevate the making of art into a substitute religion, the last bulwark of Higher Values in a materialistic world. The artist, in the 19th-century Saints' Legend, struggles against the most determined parental and social opposition, suffering the slings and arrows of social opprobrium like any Christian martyr, and ultimately succeeds against all odds—generally, alas, after his death—because from deep within himself radiates that mysterious, holy effulgence: Genius. Here we have the mad Van Gogh, spinning out sunflowers despite epileptic seizures and near-starvation; Cézanne, braving paternal rejection and public scorn in order to revolutionize painting; Gauguin throwing away respectability and financial security with a single existential gesture to pursue his Calling in the tropics, or Toulouse-Lautrec, dwarfed, crippled and alcoholic, sacrificing his aristocratic birthright in favor of the squalid surroundings that provided him with inspiration, etc.

Now no serious contemporary art historian takes such obvious fairy tales at their face value. Yet it is this sort of mythology about artistic achievement and its concomitants which forms the unconscious or unquestioned assumptions of scholars, no matter how many crumbs are thrown to social influences, ideas of the times, economic crises and so on. Behind the most sophisticated investigations of great artists—more specifically, the art-historical monograph, which accepts the notion of the Great Artist as primary, and the social and institutional structures within which he lived and worked as mere secondary "influences" or "background"—lurks

the golden-nugget theory of genius and the free-enterprise conception of individual achievement. On this basis, women's lack of major achievement in art may be formulated as a syllogism: if women had the golden nugget of artistic genius then it would reveal itself. But it has never revealed itself. QED women do not have the golden nugget of artistic genius. If Giotto, the obscure shepherd boy, and Van Gogh with his fits could make it, why not women?

Yet as soon as one leaves behind the world of fairy tale and self-fulfilling prophecy and, instead, casts a dispassionate eye on the actual situations in which important art production has existed, in the total range of its social and institutional structures throughout history, one finds that the very questions which are fruitful or relevant for the historian to ask shape up rather differently. One would like to ask, for instance, from what social classes artists were most likely to come at different periods of art history, from what castes and sub-groups. What proportion of painters and sculptors, or more specifically, of major painters and sculptors, came from families in which their fathers or other close relatives were painters and sculptors or engaged in related professions? As Nikolaus Pevsner points out in his discussion of the French Academy in the 17th and 18th centuries, the transmission of the artistic profession from father to son was considered a matter of course (as it was with the Coypels, the Coustous, the Van Loos, etc.); indeed, sons of academicians were exempted from the customary fees for lessons.[8] Despite the noteworthy and dramatically satisfying cases of the great father-rejecting *révoltés* of the 19th century, one might be forced to admit that a large proportion of artists,

great and not-so-great, in the days when it was normal for sons to follow in their fathers' footsteps, had artist fathers. In the rank of major artists, the names of Holbein and Dürer, Raphael and Bernini, immediately spring to mind; even in our own times, one can cite the names of Picasso, Calder, Giacometti and Wyeth as members of artist-families.

As far as the relationship of artistic occupation and social class is concerned, an interesting paradigm for the question "Why have there been no great women artists?" might well be provided by trying to answer the question: "Why have there been no great artists from the aristocracy?" One can scarcely think, before the anti-traditional 19th century at least, of any artist who sprang from the ranks of any more elevated class than the upper bourgeoisie; even in the 19th century, Degas came from the lower nobility—more like the haute bourgeoisie, in fact—and only Toulouse-Lautrec, metamorphosed into the ranks of the marginal by accidental deformity, could be said to have come from the loftier reaches of the upper classes. While the aristocracy has always provided the lion's share of the patronage and the audience for art—as, indeed, the aristocracy of wealth does even in our more democratic days—it has contributed little beyond amateurish efforts to the creation of art itself, despite the fact that aristocrats (like many women) have had more than their share of educational advantages, plenty of leisure and, indeed, like women, were often encouraged to dabble in the arts and even develop into respectable amateurs, like Napoleon III's cousin, the Princess Mathilde, who exhibited at the official Salons, or Queen Victoria, who, with Prince Albert, studied art with no less a

figure than Landseer himself. Could it be that the little golden nugget—Genius—is missing from the aristocratic make-up in the same way that it is from the feminine psyche? Or rather, is it not, that the kinds of demands and expectations placed before both aristocrats and women—the amount of time necessarily devoted to social functions, the very kinds of activities demanded—simply made total devotion to professional art production out of the question, indeed unthinkable, both for upper-class males and for women generally, rather than its being a question of genius and talent?

When the right questions are asked about the conditions for producing art, of which the production of great art is a sub-topic, there will no doubt have to be some discussion of the situational concomitants of intelligence and talent generally, not merely of artistic genius. Piaget and others have stressed in their genetic epistemology that in the development of reason and in the unfolding of imagination in young children, intelligence—or, by implication, what we choose to call genius—is a dynamic activity rather than a static essence, and an activity of a subject *in a situation*. As further investigations in the field of child development imply, these abilities, or this intelligence, are built up minutely, step by step, from infancy onward, and the patterns of adaptation–accommodation may be established so early within the subject-in-an-environment that they may indeed *appear* to be innate to the unsophisticated observer. Such investigations imply that, even aside from meta-historical reasons, scholars will have to abandon the notion, consciously articulated or not, of individual genius as innate, and as primary to the creation of art.[9]

The question "Why have there been no great women artists?" has led us to the conclusion, so far, that art is not a free, autonomous activity of a super-endowed individual, "influenced" by previous artists, and, more vaguely and superficially, by "social forces," but rather, that the total situation of art making, both in terms of the development of the art maker and in the nature and quality of the work of art itself, occur in a social situation, are integral elements of this social structure, and are mediated and determined by specific and definable social institutions, be they art academies, systems of patronage, mythologies of the divine creator, artist as he-man or social outcast.

The Question of the Nude

We can now approach our question from a more reasonable standpoint, since it seems probable that the answer to why there have been no great women artists lies not in the nature of individual genius or the lack of it, but in the nature of given social institutions and what they forbid or encourage in various classes or groups of individuals. Let us first examine such a simple, but critical, issue as availability of the nude model to aspiring women artists in the period extending from the Renaissance until near the end of the 19th century, a period in which careful and prolonged study of the nude model was essential to the training of every young artist, to the production of any work with pretentions to grandeur, and to the very essence of history painting, generally accepted as the highest category of art: indeed, it was argued by defenders of traditional painting in the 19th century that there could be no great painting *with* clothed figures, since costume inevitably destroyed both the temporal universality and the classical idealization required by great art. Needless to say, central to the training programs of the academies since their inception late in the 16th and early in the 17th centuries was life drawing from the nude, generally male, model. In addition, groups of artists and their pupils often met privately for life drawing sessions from the nude model in their studios. In general, it might be added, while individual artists and private academies employed the female model extensively, the female nude was forbidden in almost all public art schools as late as 1850 and

after—a state of affairs which Pevsner rightly designates as "hardly believable."[10] Far more believable, unfortunately, was the complete unavailability to the aspiring woman artist of *any* nude models at all, male or female. As late as 1893, "lady" students were not admitted to life drawing at the Royal Academy in London, and even when they were, after that date, the model had to be "partially draped."[11]

A brief survey of representations of life-drawing sessions reveals: an all male clientele drawing from the female nude in Rembrandt's studio; men working from male nudes in 18th-century representations of academic instruction in The Hague and Vienna; men working from the seated male nude in Boilly's charming painting of the interior of Houdon's studio at the beginning of the 19th century; Mathieu Cochereau's scrupulously veristic *Interior of David's Studio*, exhibited in the Salon of 1814, reveals a group of young men diligently drawing or painting from a male nude model, whose discarded shoes may be seen before the models' stand.

The very plethora of surviving "Academies"—detailed, painstaking studies from the nude studio model—in the youthful oeuvre of artists down through the time of Seurat and well into the 20th century, attests to the central importance of this branch of study in the pedagogy and development of the talented beginner. The formal academic program itself normally proceeded, as a matter of course, from copying from drawings and engravings, to drawing from casts of famous works of

Linda Nochlin

sculpture, to drawing from the living model. To be deprived of this ultimate stage of training meant, in effect, to be deprived of the possibility of creating major art works, unless one were a very ingenious lady indeed, or simply, as most of the women aspiring to be painters ultimately did, to restrict oneself to the "minor" fields of portraiture, genre, landscape or still-life. It is rather as though a medical student were denied the opportunity to dissect or even examine the naked human body.

There exist, to my knowledge, no representations of artists drawing from the nude model which include women in any role but that of the nude model itself, an interesting commentary on rules of propriety: i.e., it is all right for a ("low," of course) woman to reveal herself naked-as-an-object for a group of men, but forbidden to a woman to participate in the active study and recording of naked-man-as-an-object, or even of a fellow woman. An amusing example of this taboo on confronting a dressed lady with a naked man is embodied in a group portrait of the members of the Royal Academy in London in 1772, represented by Zoffany as gathered in the life room before two nude male models: all the distinguished members are present with but one noteworthy exception—the single female member, the renowned Angelica Kauffmann, who, for propriety's sake, is merely present in effigy, in the form of a portrait hanging on the wall. A slightly earlier drawing of *Ladies in the Studio*, by the Polish artist Daniel Chodowiecki, shows the ladies portraying a modestly dressed member of their sex. In a lithograph dating from the relatively liberated epoch following the French revolution, the lithographer Marlet has represented some women sketchers in a group

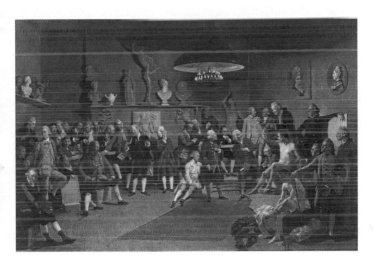

Johann Zoffany, *The Academicians
of the Royal Academy*, 1771–72.

Oil on canvas, 39⅞ × 58⅛ in.
(101.1 × 147.5 cm)

of students working from the male model, but the model himself has been chastely provided with what appears to be a pair of bathing trunks, a garment hardly conducive to a sense of classical elevation; no doubt such license was considered daring in its day, and the young ladies in question suspected of doubtful morals, but even this liberated state of affairs seems to have lasted only a short while. In an English stereoscopic color view of the interior of a studio of about 1865, the standing, bearded male model is so heavily draped that not an iota of his anatomy escapes from the discreet toga, save for a single bare shoulder and arm: even so, he obviously had the grace to avert his eyes in the presence of the crinoline-clad young sketchers.

The women in the Women's Modeling Class at the Pennsylvania Academy were evidently not allowed even this modest privilege. A photograph by Thomas Eakins of about 1885 reveals these students modeling from a cow (bull? ox? the nether regions are obscure in the photograph), a naked cow to be sure, perhaps a daring liberty when one considers that even piano legs might be concealed beneath pantalettes during this era (the idea of introducing a bovine model into the artist's studio stems from Courbet, who brought a bull into his short-lived studio academy in the 1860s). Only at the very end of the 19th century, in the relatively liberated and open atmosphere of Repin's studio and circle in Russia, do we find representations of women art students working uninhibitedly from the nude—the female model, to be sure—in the company of men. Even in this case, it must be noted that certain photographs represent a private sketch

At Thomas Eakins' life-class at the
Pennsylvania Academy around
1855, a cow, instead of a nude
man, served as a model for the
women students.

Gelatin silver print, 8⅛ × 10 in.
(20.5 × 25.4 cm)

group meeting in one of the women artists' homes; in the other, the model is draped; and the large group portrait, a co-operative effort by two men and two women students of Repin's, is an imaginary gathering together of all of the Russian realist's pupils, past and present, rather than a realistic studio view.

I have gone into the question of the availability of the nude model, a single aspect of the automatic, institutionally maintained discrimination against women, in such detail simply to demonstrate both the universality of the discrimination against women and its consequences, as well as the institutional rather than individual nature of but one facet of the necessary preparation for achieving mere proficiency, much less greatness, in the realm of art during a long stretch of time. One could equally well examine other dimensions of the situation, such as the apprenticeship system, the academic educational pattern which, in France especially, was almost the only key to success and which had a regular progression and set competitions, crowned by the Prix de Rome which enabled the young winner to work in the French Academy in that city—unthinkable for women, of course—and for which women were unable to compete until the end of the 19th century, by which time, in fact, the whole academic system had lost its importance anyway. It seems clear, to take France in the 19th century as an example, a country which probably had a larger proportion of women artists than any other—that is to say, in terms of their percentage in the total number of artists exhibiting in the Salon—that "women were not accepted as professional painters."[12] In the middle of the

century, there were only a third as many women as men artists, but even this mildly encouraging statistic is deceptive when we discover that out of this relatively meager number, *none* had attended that major stepping stone to artistic success, the École des Beaux-Arts, only 7% had received any official commission or had held any official office—and these might include the most menial sort of work—only 7% had ever received any Salon medal, and *none* had ever received the Legion of Honor.[13] Given that women were deprived of encouragements, educational facilities and rewards, it is almost incredible that a certain percentage did persevere and seek a profession in the arts.

It also becomes apparent why women were able to compete on far more equal terms with men—and even become innovators—in literature. While art-making traditionally has demanded the learning of specific techniques and skills, in a certain sequence, in an institutional setting outside the home, as well as becoming familiar with a specific vocabulary of iconography and motifs, the same is by no means true for the poet or novelist. Anyone, even a woman, has to learn the language, can learn to read and write, and can commit personal experiences to paper in the privacy of one's room. Naturally this oversimplifies the real difficulties and complexities involved in creating good or great literature, whether by man or woman, but it still gives a clue as to the possibility of the existence of Emily Brönte or an Emily Dickinson, and the lack of their counterparts, at least until quite recently, in the visual arts.

Of course we have not gone into the "fringe" requirements for major artists, which would have been, for the most

part, both psychically and socially closed to women, even if hypothetically they could have achieved the requisite grandeur in the performance of their craft: in the Renaissance and after, the great artist, aside from participating in the affairs of an academy, might well be intimate with members of humanist circles with whom he could exchange ideas, establish suitable relationships with patrons, travel widely and freely, perhaps engage in politics and intrigue; nor have we mentioned the sheer organizational acumen and ability involved in running a major studio-factory, like that of Rubens. An enormous amount of self-confidence and worldly knowledgeability, as well as a natural sense of well-earned dominance and power, was needed by the great *chef d'école*, both in the running of the production end of painting, and in the control and instruction of the numerous students and assistants.

The Lady's Accomplishment

In contrast to the single-mindedness and commitment demanded of a *chef d'école*, we might set the image of the "lady painter" established by 19th-century etiquette books and reinforced by the literature of the times. It is precisely the insistence upon a modest, proficient, self-demeaning level of amateurism as a "suitable accomplishment" for the well-brought-up young woman, who naturally would want to direct her major attention to the welfare of others—family and husband—that militated, and still militates, against any real accomplishment on the part of women. It is this emphasis which transforms serious commitment to frivolous self-indulgence, busy work or occupational therapy, and today, more than ever, in suburban bastions of the feminine mystique, which tends to distort the whole notion of what art is and what kind of social role it plays. In Mrs. Ellis' widely read *The Family Monitor and Domestic Guide*, published before the middle of the 19th century, a book of advice popular both in the United States and in England, women were warned against the snare of trying too hard to excel in any one thing:

It must not be supposed that the writer is one who would advocate, as essential to woman, any very extraordinary degree of intellectual attainment, especially if confined to one particular branch of study. "I should like to excel in something" is a frequent and, to some extent, laudable expression: but in what does it originate, and to what does it tend? *To be able to do a great many things tolerably well, is of infinitely more value to a woman, than to be able to excel in any one. By the former,*

she may render herself generally useful; by the latter, she may dazzle for an hour. By being apt. and tolerably well skilled in everything, she may fall into any situation in life with dignity and ease—by devoting her time to excellence in one, she may remain incapable of every other.

So far as cleverness, learning, and knowledge are conducive to woman's moral excellence, they are therefore desirable, and no further. *All that would occupy her mind to the exclusion of better things, all that would involve her in the mazes of flattery and admiration, all that would tend to draw away her thoughts from others and fix them on herself, ought to be avoided as an evil to her, however brilliant or attractive it may be in itself.* [my italics][14]

Lest we are tempted to laugh, we may refresh ourselves with more recent samples of exactly the same message cited in Betty Friedan's *Feminine Mystique*, or in the pages of recent issues of popular women's magazines.

This advice has a familiar ring, of course: propped up by a bit of Freudianism and some tag-lines from the social sciences about the well-rounded personality, preparation for woman's chief career, marriage, and the unfemininity of deep involvement with work rather than sex, it is still the mainstay of the Feminine Mystique. Such an outlook helps guard man from unwanted competition in his "serious" professional activities and assures him of "well-rounded" assistance on the home front, so that he may have sex and family in addition to the fulfillment of his own specialized talent and excellence at the same time.

As far as painting specifically is concerned, Mrs. Ellis finds that it has one immediate advantage for the young lady over its rival branch of artistic activity, music—it is quiet and

disturbs no one (this negative virtue, of course, would not be true of sculpture, but accomplishment with the hammer and chisel simply never occurs as a suitable accomplishment for the weaker sex); in addition, says Mrs. Ellis, "it [drawing] is an employment which beguiles the mind of many cares… Drawing is, of all other occupations, the one most calculated to keep the mind from brooding upon self, and to maintain that general cheerfulness which is a part of social and domestic duty…It can also," she adds, "be laid down and resumed, as circumstance or inclination may direct, and that without any serious loss."[15] Again, lest we feel that we have made a great deal of progress in this area in the past 100 years, I might bring up the remark of a bright young doctor who, when the conversation turned to his wife and her friends "dabbling" in the arts, snorted: "Well, at least it keeps them out of trouble!" Now as in the 19th century, amateurism and lack of real commitment, as well as snobbery and emphasis on chic, on the part of women in their artistic "hobbies" feeds the contempt of the successful, professionally committed man who is engaged in "real" work and can, with a certain justice, point to his wife's lack of seriousness in her artistic activities. For such men, the "real" work of women is only that which directly or indirectly serves the family; any other commitment falls under the rubric of diversion, selfishness, egomania or, at the unspoken extreme, castration. The circle is a vicious one, in which philistinism and frivolity mutually re-enforce each other.

In literature, as in life, even if the woman's commitment to art was a serious one, she was expected to drop her career and give up this commitment at the behest of love and marriage:

this lesson is, today as in the 19th century, still inculcated in young girls, directly or indirectly, from the moment they are born. Even the determined and successful heroine of Mrs. Craik's mid-19th-century novel about feminine artistic success, *Olive*, a young woman who lives alone, strives for fame and independence and actually supports herself through her art—such unfeminine behavior is at least partly excused by the fact that she is a cripple and automatically considers that marriage is denied to her—ultimately succumbs to the blandishments of love and marriage. To paraphrase the words of Patricia Thomson in *The Victorian Heroine*, Mrs. Craik, having shot her bolt in the course of her novel, is content, finally, to let her heroine, whose ultimate greatness the reader has never been able to doubt, sink gently into matrimony, "Of Olive, Mrs. Craik comments imperturbably that her husband's influence is to deprive the Scottish Academy of 'no one knew how many grand pictures.'"[16] Then as now, despite men's greater "tolerance," the choice for women seems always to be marriage *or* a career, i.e., solitude as the price of success *or* sex and companionship at the price of professional renunciation.

That achievement in the arts, as in any field of endeavor, demands struggle and sacrifice, no one would deny; that this has certainly been true after the middle of the 19th century, when the traditional institutions of artistic support and patronage no longer fulfilled their customary obligations, is undeniable: one has only to think of Delacroix, Courbet, Degas, Van Gogh and Toulouse-Lautrec as examples of great artists who gave up the distractions and obligations of family life, at least in part, so that they could pursue their artistic careers more single-mindedly.

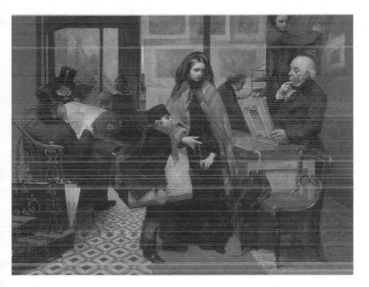

Emily Mary Osborn,
Nameless and Friendless, 1857.

Oil on canvas, 32½ × 40⅞ in.
(82.5 × 103.8 cm)

Maurice Bompard,
Un debut à l'atelier, 1881.

Oil on canvas, 88⅝ × 166⅛ in.
(225 × 422 cm)

Yet none of them was automatically denied the pleasures of sex or companionship on account of this choice. Nor did they ever conceive that they had sacrificed their manhood or their sexual role on account of their singleness and single-mindedness in order to achieve professional fulfillment. But if the artist in question happens to be a woman, 1,000 years of guilt, self-doubt and objecthood have been added to the undeniable difficulties of being an artist in the modern world.

As an example of the unconscious aura of titillation that arises from a visual representation of an aspiring woman artist in the mid-19th century, Emily Mary Osborn's heart-felt painting, *Nameless and Friendless*, 1857 [p. 59], a canvas representing a poor but lovely and respectable young girl at a London art dealer, nervously awaiting the verdict of the pompous proprietor about the worth of her canvases while two ogling "art lovers" look on, is really not too different in its underlying assumptions from an overtly salacious work like Bompard's *Un début à l'atelier*. The theme in both is innocence, delicious feminine innocence, exposed to the world. It is the charming *vulnerability* of the young woman artist, like that of the hesitating model, which is really the subject of Miss Osborn's painting, not the value of the young woman's work or her pride in it: the issue here is, as usual, sexual rather than serious. Always a model but never an artist might well have served as the motto of the seriously aspiring young woman in the arts of the 19th century.

Berthe Morisot, *Eugene Manet on the Isle of Wight*, 1875.

Oil on canvas, 15 × 18⅛ in. (38 × 46 cm)

Successes

But what of the small band of heroic women, who, through-
out the ages, despite obstacles, have achieved pre-eminence, if
not the pinnacles of grandeur of a Michelangelo, a Rembrandt
or a Picasso? Are there any qualities that may be said to have
characterized them as a group and as individuals? While we
cannot go into such an investigation in depth in this article,
we can point to a few striking characteristics of women artists
generally: they all, almost without exception, were either
the daughters of artist fathers, or, generally later, in the 19th
and 20th centuries, had a close personal connection with a
stronger or more dominant male artistic personality. Neither
of these characteristics is, of course, unusual for men artists,
either, as we have indicated above in the case of artist fathers
and sons: it is simply true almost *without exception* for their
feminine counterparts, at least until quite recently. From
the legendary sculptor, Sabina von Steinbach, in the 13th
century, who, according to local tradition, was responsible
for South Portal groups on the Cathedral of Strasbourg, down
to Rosa Bonheur, the most renowned animal painter of the
19th century, and including such eminent women artists as
Marietta Robusti, daughter of Tintoretto, Lavinia Fontana,
Artemisia Gentileschi, Elizabeth Chéron, Mme. Vigée Le
Brun and Angelica Kauffmann—all, without exception, were
the daughters of artists; in the 19th century, Berthe Morisot
was closely associated with Manet, later marrying his brother,
and Mary Cassatt based a good deal of her work on the style
of her close friend Degas. Precisely the same breaking of

traditional bonds and discarding of time-honored practices
that permitted men artists to strike out in directions quite
different from those of their fathers in the second half of the
19th century enabled women, with additional difficulties,
to be sure, to strike out on their own as well. Many of our
more recent women artists, like Suzanne Valadon, Paula
Modersohn-Becker, Käthe Kollwitz or Louise Nevelson,
have come from non-artistic backgrounds, although many
contemporary and near-contemporary women artists have
married fellow artists.

It would be interesting to investigate the role of benign,
if not outright encouraging, fathers in the formation of
women professionals: both Käthe Kollwitz and Barbara
Hepworth, for example, recall the influence of unusually
sympathetic and supportive fathers on their artistic pursuits.
In the absence of any thoroughgoing investigation, one
can only gather impressionistic data about the presence or
absence of rebellion against parental authority in women
artists, and whether there may be more or less rebellion on
the part of women artists than is true in the case of men or
vice versa. One thing however is clear: for a woman to opt
for a career at all, much less for a career in art, has required
a certain amount of unconventionality, both in the past
and at present; whether or not the woman artist rebels
against or finds strength in the attitude of her family, she
must in any case have a good strong streak of rebellion in
her to make her way in the world of art at all, rather than
submitting to the socially approved role of wife and mother,
the only role to which every social institution consigns her

automatically. It is only by adopting, however covertly, the "masculine" attributes of single-mindedness, concentration, tenaciousness and absorption in ideas and craftsmanship for their own sake, that women have succeeded, and continue to succeed, in the world of art.

Rosa Bonheur

It is instructive to examine in greater detail one of the most successful and accomplished women painters of all time, Rosa Bonheur (1822–1899), whose work, despite the ravages wrought upon its estimation by changes of taste and a certain admitted lack of variety, still stands as an impressive achievement to anyone interested in the art of the 19th century and in the history of taste generally. Rosa Bonheur is a woman artist in whom, partly because of the magnitude of her reputation, all the various conflicts, all the internal and external contradictions and struggles typical of her sex and profession, stand out in sharp relief.

The success of Rosa Bonheur firmly establishes the role of institutions, and institutional change, as a necessary, if not a sufficient cause of achievement in art. We might say that Bonheur picked a fortunate time to become an artist if she was, at the same time, to have the disadvantage of being a woman: she came into her own in the middle of the 19th century, a time in which the struggle between traditional history painting as opposed to the less pretentious and more freewheeling genre painting, landscape and still-life was won by the latter group hands down. A major change in the social and institutional support for art itself was well under way: with the rise of the bourgeoisie and the fall of the cultivated aristocracy, smaller paintings, generally of everyday subjects, rather than grandiose mythological or religious scenes were much in demand. To cite the Whites: "Three hundred provincial museums there might be, government commissions

for public works there might be, but the only possible paid destinations for the rising flood of canvases were the homes of the bourgeoisie. History painting had not and never would rest comfortably in the middle-class parlor. 'Lesser' forms of image art—genre, landscape, still life did."[17] In mid-century France, as in 17th-century Holland, there was a tendency for artists to attempt to achieve some sort of security in a shaky market situation by specializing, by making a career out of a specific subject: animal painting was a very popular field, as the Whites point out, and Rosa Bonheur was no doubt its most accomplished and successful practitioner, followed in popularity only by the Barbizon painter Troyon (who at one time was so pressed for his paintings of cows that he hired another artist to brush in the backgrounds). Rosa Bonheur's rise to fame accompanied that of the Barbizon landscapists, supported by those canny dealers, the Durand-Ruels, who later moved on to the Impressionists. The Durand-Ruels were among the first dealers to tap the expanding market in movable decoration for the middle classes, to use the Whites' terminology. Rosa Bonheur's naturalism and ability to capture the individuality—even the "soul"—of each of her animal subjects coincided with bourgeois taste at the time. The same combination of qualities, with a much stronger dose of sentimentality and pathetic fallacy to be sure, likewise assured the success of her *animalier* contemporary, Landseer, in England.

Daughter of an impoverished drawing master, Rosa Bonheur quite naturally showed her interest in art early; at

the same time, she exhibited an independence of spirit and liberty of manner which immediately earned her the label of tomboy. According to her own later accounts, her "masculine protest" established itself early; to what extent *any* show of persistence, stubbornness and vigor would be counted as "masculine" in the first half of the 19th century is conjectural. Rosa Bonheur's attitude toward her father is somewhat ambiguous: while realizing that he had been influential in directing her toward her life's work, there is no doubt that she resented his thoughtless treatment of her beloved mother, and in her reminiscences, she half affectionately makes fun of his bizarre form of social idealism. Raimond Bonheur had been an active member of the short-lived Saint-Simonian community, established in the third decade of the 19th century by "Le Pére" Enfantin at Menilmontant. Although in her later years Rosa Bonheur might have made fun of some of the more far-fetched eccentricities of the members of the community, and disapproved of the additional strain which her father's apostolate placed on her overburdened mother, it is obvious that the Saint-Simonian ideal of equality for women—they disapproved of marriage, their trousered feminine costume was a token of emancipation, and their spiritual leader, Le Père Enfantin, made extraordinary efforts to find a Woman Messiah to share his reign—made a strong impression on her as a child, and may well have influenced her future course of behavior.

"Why shouldn't I be proud to be a woman?" she exclaimed to an interviewer. "My father, that enthusiastic apostle of humanity, many times reiterated to me that

woman's mission was to elevate the human race, that she
was the Messiah of future centuries. It is to his doctrines
that I owe the great, noble ambition I have conceived for
the sex which I proudly affirm to be mine, and whose
independence I will support to my dying day…"[18] When
she was hardly more than a child, he instilled in her the
ambition to surpass Mme. Vigée Le Brun, certainly the
most eminent model she could be expected to follow, and
he gave her early efforts every possible encouragement.
At the same time, the spectacle of her uncomplaining moth-
er's slow decline from sheer overwork and poverty might
have been an even more realistic influence on her decision
to control her own destiny and never to become the slave
of a husband and children. What is particularly interesting
from the modern feminist viewpoint is Rosa Bonheur's ability
to combine the most vigorous and unapologetic masculine
protest with unabashedly self-contradictory assertions of
"basic" femininity.

In those refreshingly straightforward pre-Freudian
days, Rosa Bonheur could explain to her biographer that
she had never wanted to marry for fear of losing her inde-
pendence—too many young girls let themselves be led to
the altar like lambs to the sacrifice, she maintained. Yet at the
same time that she rejected marriage for herself and implied
an inevitable loss of selfhood for any woman who engaged
in it, she, unlike the Saint-Simonians, considered marriage
"a sacrament indispensable to the organization of society."

While remaining cool to offers of marriage, she joined in
a seemingly cloudless, lifelong and apparently Platonic union

with a fellow woman artist, Nathalie Micas, who evidently provided her with the companionship and emotional warmth which she needed. Obviously the presence of this sympathetic friend did not seem to demand the same sacrifice of genuine commitment to her profession which marriage would have entailed: in any case, the advantages of such an arrangement for women who wished to avoid the distraction of children in the days before reliable contraception are obvious.

Yet at the same time that she frankly rejected the conventional feminine role of her times, Rosa Bonheur still was drawn into what Betty Friedan has called the "frilly blouse syndrome," that innocuous version of the feminine protest which even today compels successful women psychiatrists or professors to adopt some ultra-feminine item of clothing or insist on proving their prowess as pie-bakers.[19] Despite the fact that she had early cropped her hair and adopted men's clothes as her habitual attire, following the example of George Sand, whose rural romanticism exerted a powerful influence over her imagination, to her biographer she insisted, and no doubt sincerely believed, that she did so only because of the specific demands of her profession. Indignantly denying rumors to the effect that she had run about the streets of Paris dressed as a boy in her youth, she proudly provided her biographer with a daguerreotype of herself at sixteen years, dressed in perfectly conventional feminine fashion except for her shorn head, which she excused as a practical measure taken after the death of her mother; "Who would have taken care of my curls?" she demanded.[20]

As far as the question of masculine dress was concerned, she was quick to reject her interlocutor's suggestion that her trousers were a symbol of emancipation. "I strongly blame women who renounce their customary attire in the desire to make themselves pass for men," she affirmed. "If I had found that trousers suited my sex, I would have completely gotten rid of my skirts, but this is not the case, nor have I ever advised my sisters of the palette to wear men's clothes in the ordinary course of life. If, then, you see me dressed as I am, it is not at all with the aim of making myself interesting, as all too many women have tried, but simply in order to facilitate my work. Remember that at a certain period I spent whole days in the slaughterhouses. Indeed, you have to love your art in order to live in pools of blood...I was also fascinated with horses, and where better can one study these animals than at the fairs...? I had no alternative but to realize that the garments of my own sex were a total nuisance. That is why I decided to ask the Prefect of Police for the authorization to wear masculine clothing.[21] But the costume I am wearing is my working outfit, nothing else. The remarks of fools have never bothered me. Nathalie [her companion] makes fun of them as I do. It doesn't bother her at all to see me dressed as a man, but if you are even the slightest bit put off, I am completely prepared to put on a skirt, especially since all I have to do is to open a closet to find a whole assortment of feminine outfits."[22]

Yet at the same time Rosa Bonheur is forced to admit: "My trousers have been my great protectors...Many times I have congratulated myself for having dared to break with

traditions which would have forced me to abstain from certain kinds of work, due to the obligation to drag my skirts everywhere…" Yet the famous artist again feels obliged to qualify her honest admission with an ill-assumed "femininity": "Despite my metamorphoses of costume, there is not a daughter of Eve who appreciates the niceties more than I do: my brusque and even slightly unsociable nature has never prevented my heart from remaining completely feminine."[23]

It is somewhat pathetic that this highly successful artist, unsparing of herself in the painstaking study of animal anatomy, diligently pursuing her bovine or equine subjects in the most unpleasant surroundings, industriously producing popular canvases throughout the course of a lengthy career, firm, assured and incontrovertibly masculine in her style, winner of a first medal in the Paris Salon, Officer of the Legion of Honor, Commander of the Order of Isabella the Catholic and the Order of Leopold of Belgium, friend of Queen Victoria—that this world-renowned artist should feel compelled late in life to justify and qualify her perfectly reasonable assumption of masculine ways, for any reason whatsoever, and to feel compelled to attack her less modest trouser-wearing sisters at the same time, in order to satisfy the demands of her own conscience. For her conscience, despite her supportive father, her unconventional behavior and the accolade of worldly success, still condemned her for not being a "feminine" woman.

The difficulties imposed by such demands on the woman artist continue to add to her already difficult enterprise even today. Compare, for example, the noted contemporary, Louise

Rosa Bonheur, *The Horse Fair*, 1852–55.
Oil on canvas, 96⅜ × 199½ in. (244.5 × 506.7 cm)

Nevelson, with her combination of utter, "unfeminine" ded-
ication to her work and her conspicuously "feminine" false
eyelashes: her admission that she got married at seventeen
despite her certainty that she couldn't live without creating
because "the world said you should get married."[24] Even in
the case of these two outstanding artists—and whether we like
The Horse Fair or not, we still must admire Rosa Bonheur's
achievement—the voice of the feminine mystique with its
potpourri of ambivalent narcissism and guilt, internalized,
subtly dilutes and subverts that total inner confidence, that
absolute certitude and self-determination, moral and esthetic,
demanded by the highest and most innovative work in art.

Conclusion

We have tried to deal with one of the perennial questions used to challenge women's demand for true, rather than token, equality, by examining the whole erroneous intellectual substructure upon which the question "Why have there been no great women artists?" is based; by questioning the validity of the formulation of so-called "problems" in general and the "problem" of women specifically; and then, by probing some of the limitations of the discipline of art history itself. Hopefully, by stressing the *institutional*—i.e. the public—rather than the *individual,* or private, pre-conditions for achievement or the lack of it in the arts, we have provided a paradigm for the investigation of other areas in the field. By examining in some detail a single instance of deprivation or disadvantage—the unavailability of nude models to women art students—we have suggested that it was indeed *institutionally* made impossible for women to achieve artistic excellence, or success, on the same footing as men, *no matter what* the potency of their so-called talent, or genius. The existence of a tiny band of successful, if not great, women artists throughout history does nothing to gainsay this fact, any more than does the existence of a few superstars or token achievers among the members of any minority groups. And while great achievement is rare and difficult at best, it is still rarer and more difficult if, while you work, you must at the same time wrestle with inner demons of self-doubt and guilt and outer monsters of ridicule or patronizing encouragement, neither of which have any specific connection with the quality of the art work as such.

What is important is that women face up to the reality of their history and of their present situation, without making excuses or puffing mediocrity. Disadvantage may indeed be an excuse; it is not, however, an intellectual position. Rather, using as a vantage point their situation as underdogs in the realm of grandeur, and outsiders in that of ideology, women can reveal institutional and intellectual weaknesses in general, and, at the same time that they destroy false consciousness, take part in the creation of institutions in which clear thought—and true greatness—are challenges open to anyone, man or woman, courageous enough to take the necessary risk, the leap into the unknown.

"Why Have There Been No Great Women Artists?" Thirty Years After

Women Artists at the Millennium, 2006

I'd like to roll the clock back to November 1970, a time when there were no women's studies, no feminist theory, no African American studies, no queer theory, no postcolonial studies. What there was was Art I or Art 105—a seamless web of great art, often called "The Pyramids to Picasso"—that unrolled fluidly in darkened rooms throughout the country, extolling great (male, of course) artistic achievement since the very dawn of history. In art journals of record, like *ARTnews*,[1] out of a total of eighty-one major articles on artists, just two were devoted to women painters. In the following year, ten out of eighty-four articles were devoted to women,[2] but that includes the nine articles in the special Woman Issue in January, in which "Why Have There Been No Great Women Artists?" appeared; without that issue, the total would have been one out of eighty-four. *Artforum* of 1970–71 did a little better: five articles on women out of seventy-four.

Things have certainly changed in academia and the art world, and I would like to direct my attention to those changes, a revolution that no one article or event could possibly have achieved, but that was a totally communal affair and, of course, overdetermined. "Why Have There Been No Great Women Artists?" was conceived during the heady days of the birth of the Women's Liberation movement in 1970 and shares the political energy and the optimism of the period. It was at least partially based on research carried out the previous year, when I had conducted the first seminar at Vassar College on women and art. It was intended for publication in one of the earliest scholarly texts of the feminist movement, *Women in Sexist Society*,[3] edited by Vivian Gornick and Barbara Moran, but appeared first as a richly illustrated article in the pioneering, and controversial, issue of *ARTnews* edited by Elizabeth Baker and dedicated to women's issues.[4]

What were some of the goals and aims of the women's movement in art in these early days? A primary goal was to change or displace the traditional, almost entirely male-oriented notion of "greatness" itself. There had been a particular and recent historical reconsecration of the cultural ideal of greatness in the United States in the 1950s and 60s, a reconsecration that, I must admit, I was not consciously aware of when I wrote the article, but which surely must have colored my thinking about the issue. As Louis Menand pointed out in a recent *New Yorker* article dedicated to the Readers' Subscription Book Club, initiated in 1951, "What dates the essays [used to preface the book club selections and written by such certified experts as Lionel Trilling, WH Auden, and Jacques Barzun] is

not that they are better written or less given to 'the Theoretical' than contemporary criticism. It is their incessant invocation of 'greatness.' It is almost a crutch, as though 'How great is it?' were the only way to begin a conversation about a work of art."[5] Tied to the idea of greatness was the idea that it was immutable and that it was the particular possession of the white male and his works, although the latter was unstated. In the post-Second World War years, greatness was constructed as a sex-linked characteristic in the cultural struggle in which the promotion of "intellectuals" was a cold war priority, "at a time when a dominant strategic concern was the fear of losing Western Europe to Communism."[6]

Today, I believe it is safe to say that most members of the art world are far less ready to worry about what is great and what is not, nor do they assert as often the necessary connection of important art with virility or the phallus. No longer is it the case that the boys are the important artists, the girls positioned as appreciative muses or groupies. There has been a change in what counts—from phallic "greatness" to being innovative, making interesting, provocative work, making an impact, and making one's voice heard. There is less and less emphasis on the masterpiece, more on the piece. While "great" may be a shorthand way of talking about high importance in art, it seems to me always to run the risk of obscurantism and mystification. How can the same term "great"—or "genius," for that matter— account for the particular qualities or virtues of an artist like Michelangelo and one like Duchamp, or, for that matter, within a narrower perimeter, Manet and Cézanne? There has been a change in the discourse about contemporary art.

Greatness, like beauty, hardly seems an issue for postmodern ism, with whose coming of age "Why Have There Been No Great Women Artists?" coincided.

The impact of theory on art discourse and especially feminist and/or gender-based discourse is another change. When I wrote "Why Have There Been No Great Women Artists?," theory in its now accepted form did not exist for art historians, or if it did, I was not aware of it: the Frankfurt school—yes; Freud—up to a point; but Lacan and French feminism were little dots on the horizon, as far as I could tell. Within academia, and in the art world to a certain extent, that impact has since been enormous. It, of course, has changed our way of thinking about art—and gender and sexuality themselves. What effect it has had on a feminist politics of art is, perhaps, more ambiguous, and needs consideration. It has certainly acted to cut the wider public off from a great deal of the hot issues discussed by in-the-know art historians and critics.

If the ideal of the great artist is no longer as prominent as it once was, there have nevertheless been some extraordinary, large-scale, and long-lasting careers in art to be dealt with, some old-style grandeur that has flourished in the work of women artists in recent years. First of all, there is the career of Joan Mitchell. Her work has sometimes been dismissed as "second-generation" abstract expressionism, with the implica tion that she was not an inventor or that she lacked originality, the cardinal insignia of modernist greatness. Yet why should it not be possible to consider this belatedness as a culmination, the culmination of the project of painterly abstraction that had come before? Think of Johann Sebastian Bach in relation

to the baroque counterpoint tradition; the "Art of Fugue" might have been created at the end of a stylistic period, but surely it was the grandest of grand finales, at a time when originality was not so highly prized. Or, one might think of Mitchell's position as parallel to Berthe Morisot's in relation to classical Impressionism: a carrying farther of all that was implicit in the movement.

In the case of Louise Bourgeois, another major figure of our era, we have quite a different situation: nothing less than the transformation of the canon itself in terms of certain feminist or, at least, gender-related priorities. It is no accident that Bourgeois' work has given rise to such a rich crop of critical discourse by mostly theory-based women writers: Rosalind Krauss, Mignon Nixon, Anne Wagner, Griselda Pollock, Mieke Bal, Briony Fer, and others. For Bourgeois has transformed the whole notion of sculpture, including the issue of gendered representation of the body as central to the work. In addition, the discourse on Bourgeois must confront two of the major "post-greatness" points of debate of our time: the role of biography in the interpretation of the artwork; and the new importance of the abject, the viscous, the formless, or the polyform.

Bourgeois' work is characterized by a brilliant quirkiness of conception and imagination in relation to the materiality and structure of sculpture itself. This, of course, problematizes the viewing of her pieces. Indeed, as Alex Potts (whom I will take as an honorary woman in this situation) has stated, "One of the more characteristic and intriguing features of Louise Bourgeois' work is the way it stages such a vivid

psychodynamics of viewing," And he continues, "There seems to be an unusual attentiveness on her part to the structure of a viewer's encounter with three-dimensional art works in a modern gallery setting as well as to the forms of psychic phantasy activated in such interactions between viewer and work."[7]

It is important to realize that although Bourgeois had been working since the 1940s, she did not really come into prominence and recognition until the 70s, in the wake of the women's movement. I remember walking to my seat with her at one of the early, large-scale women's meetings and telling her about my plan to match a 19th-century photograph, *Buy My Apples* with a male equivalent—well, maybe, *Buy My Sausages*. Louise said, "Why not bananas?" and an icon was born—at least I think it happened that way.

A younger generation of women artists often engages with ways of undermining the representational doxa that may be subtle or violent. Not the least achievement of Mary Kelly, for example, in her innovative *Post-Partum Document* [p. 88], was the way it desublimated Clement Greenberg's famous dictum, that the final step in the teleology of modernist art is simply the stain on the surface of the canvas, by reducing that stain to a smear of baby's shit on the surface of a diaper. Cindy Sherman, to take another example, sent up the movie still, making strange this most conventional of genres, and later shattered the idea of the body as a whole, natural, coherent entity with an imagery characterized by grotes-query, redundancy, and abjection. Yet, I would venture that Sherman's photographs also create a fierce new anti-beauty,

Mary Kelly, *Post-Partum Document: Documentation I,
Analysed Faecal Stains and Feeding Charts*, 1974.

Perspex unit, white card, diaper linings, plastic, sheeting,
paper, ink, 1 of 31 units, 11 × 14 in. (28 × 35.5 cm)

making Bellmer look positively pastoral, but in particular pulling the carpet out from under such admired painterly subverters of canonical femininity as de Kooning or Dubuffet.

Another profound change that has taken place is that of the relation of women to public space and its public monuments. This relationship has been problematic since the beginning of modern times. The very asymmetry of our idiomatic speech tells us as much; a public man (as in Richard Sennett's *The Fall of Public Man*) is an admirable person, politically active, socially engaged, known, and respected. A public woman, on the contrary, is the lowest form of prostitute. And women, historically, have been confined to and associated with the domestic sphere in social theory and in pictorial representation.

Things certainly began to change, if at a slow pace, in the 20th century, with the advent of the "New Woman": the working woman and the suffrage movement, as well as the entry of women—in limited numbers to be sure—into the public world of business and the professions. Yet this change is reflected more in literature than in the visual arts. As Deborah Parsons has demonstrated in her important study of the phenomenon, *Streetwalking the Metropolis: Women, the City and Modernity*, novels like Dorothy Richardson's *Pilgrimage* or Virginia Woolf's *Night and Day* or *The Years* represented women engaging with the city in newer, freer ways—as watchers, walkers, workers, denizens of cafés and clubs, apartment dwellers, observers and negotiators of the public space of the city—breaking new ground without the help of tradition, literary or otherwise.

But, it was not until the late 1960s and early 70s that women as a group, as activists rather than mere *flâneuses*, really took over public space for themselves, marching for a woman's right to control her own body as their grandmothers had marched for the vote. And, not coincidentally, as Luc Nadal points out in his 2000 Columbia dissertation, "Discourses of Public Space: USA 1960–1995: A Historical Critique," the term "public space" itself began to be used by architects, urban designers, historians, and theoreticians at just this time. Says Nadal, "The rise of 'public space' in the 1960s corresponded to a shift at the center of the discourse of planning and design." Nadal connects this project with the "vast movement of liberatory culture and politics of the 1960s and early 70s." It is within this context of liberatory culture and politics that we must consider woman not merely as a visible presence in public space, but in her practice as a highly visible and original shaper and constructor of it. For women today play a major role in the construction of public sculpture and urban monuments. And, these monuments are of a new and different sort, inassimilable to those of the past, often centers of controversy. Some have called them anti-monuments. Rachel Whiteread, for example, recreated a condemned house on a bleak plot in London, turning the architecture inside out and creating a storm of reaction and public opinion. A temporary anti-monument, it was later destroyed amid equal controversy. Whiteread's recent *Holocaust Memorial* in Vienna at the Judenplatz also turns both subject and form inside out, forcing the viewer not only to contemplate the fate of the Jews, but to rethink the meaning of

Rachel Whiteread, *Holocaust
Memorial*, 2000. Judenplatz, Vienna.

Concrete, 150 × 276 × 394 in.
(380 × 700 × 1000 cm)

Jenny Holzer, *Memorial Café to
Oskar Maria Graf*, Munich, 1997.

the monumental itself by setting the memorial in the heart of Vienna, one of the major sites of their extermination.

Jenny Holzer, using both words and traditional and untraditional materials, also created scandals in Munich and Leipzig with her provocative public works. Her 1997 *Memorial Café to Oskar Maria Graf*, a German poet, exists as a functional café at the Literaturhaus in Munich. This is, to borrow the words of doctoral student Leah Sweet, a "conceptual memorial [that] refuses to present its subject…through a likeness or a biographic account of his life and work." Rather, Graf is represented through excerpts of his writing selected by Holzer and scattered throughout the café. Shorter excerpts appear on dishes, place mats, and coasters—an ironic use of what one might call the domestic-abject mode of memorialization!

Maya Lin is probably the foremost and best known of these women inventors of new monuments with new meanings and, above all, with new, untried ways of conveying meaning and feeling in public places. Lin's own words best convey her unconventional intentions and her anti-monumental achievement in this most public of memorials: "I imagined taking a knife and cutting into the earth, opening it up, an initial violence and pain that in time would heal. The grass would grow back, but the initial cut would remain a pure flat surface in the earth with a polished mirrored surface…the need for the names to be on the memorial would become the memorial; there was no need to embellish the design further. The people and their names would allow everyone to respond and remember."[8] Still another unconventional public memorial is Lin's *The Women's Table* [p. 95], a water table created in the

heart of Yale's urban campus in 1993, commemorating with words, stone, and water the admission of women to Yale in 1969. It is a strong but gentle monument, asserting women's increasing presence at Yale itself, but also commemorating in more general terms women's emergent place in modern society. Yet, despite its assertive message inscribed in facts and figures on its surface, *The Women's Table* is at one with its surroundings. Although it constitutes a critical intervention into public space, its effect vis-à-vis that space is very different from that of a work like Richard Serra's controversial *Tilted Arc* of 1981. Lin's Yale project, like her Vietnam memorial, establishes a very different relationship to the environment and to the meaning and function of the public monument than Serra's aggressive confrontation with public space. I am not coming out for a "feminine" versus a "masculine" style of public monument with this comparison. I am merely returning to the theme of this session and suggesting that now, as in the 19th century, although in very different circumstances, women may have—and wish to construct—a very different experience of public space and the monuments that engage with it than their male counterparts.

I would next like to consider very briefly the dominance of women's production in a wide variety of media that are not painting or sculpture in the traditional sense, and above all, the role of women artists in breaking down the barriers between media and genres in exploring new modes of investigation and expression. These are all women artists who might be said to be inventing new media or, to borrow a useful phrase from critic George Baker, "occupying a space *between* mediums."[9]

Maya Lin, *The Women's Table*,
1993. Yale University, New Haven.

The list would include installation artists like Ann Hamilton, who has made the wall weep and the floor sprout hair, and the photographer Sam Taylor-Wood, working with the enlarged and/or altered photo, who produces "cinematic photographs or video-like films."[10] This list of innovators would include innovative users of photography like Carrie Mae Weems, video and film inventors such as Pipilotti Rist and Shirin Neshat, performance artists like Janine Antoni, or such original and provocative recyclers of old practices as Kara Walker, who has created the postmodern silhouette with a difference.

Finally, although I can only hint at it, I would like to indicate the impact, conscious or unconscious, of the new women's production on the work of male artists. The recent emphasis on the body, the rejection of phallic control, the exploration of psychosexuality, and the refusal of the perfect, the self-expressive, the fixed, and the domineering are certainly to some degree implicated, however indirectly, with what women have been doing. Yes, in the beginning was Duchamp, but it seems to me that many of the most radical and interesting male artists working today have, in one way or another, felt the impact of that gender-bending, body-conscious wave of thought generated by women artists, overtly feminist or not. William Kentridge's films, with their insistent metamorphoses of form, fluidity of identity, and melding of the personal and the political, seem to me unthinkable without the anterior presence of feminist, or women's, art. Would the work of male performance and video artists, abjectifiers, or decorative artists have been the same without the enormous impact and alteration of the stakes and the meanings of art

Kara Walker, *Gone: An Historical Romance of a Civil War as it Occurred b'tween the Dusky Thighs of One Young Negress and Her Heart*, 1994.

Cut paper on wall. Installation dimensions variable; approximately 156 × 600 in. (396.2 × 1524 cm)

production in the 1970s, 80s, and 90s that were produced by women's innovations?

Women artists, women art historians, and women critics have made a difference, then, over the past thirty years. We have—as a community, working together—changed the discourse and the production of our field. Things are not the same as they were in 1971 for women artists and the people who write about them. There is a whole flourishing area of gender studies in the academy, a whole production of critical representation that engages with issues of gender in the museums and art galleries. Women artists, of all kinds, are talked about, looked at, have made their mark—and this includes women artists of color.

Yet, there is still, again, a long way to go. Critical practice must, I think, remain at the heart of our enterprise. In 1988, in the introduction to *Women, Art and Power*, I wrote,

Critique has always been at the heart of my project and remains there today. I do not conceive of a feminist art history as a "positive" approach to the field, a way of simply adding a token list of women painters and sculptors to the canon, although such recuperation of lost production and lost modes of productivity has its own historical validity and…can function as part of the questioning of the conventional formulation of the parameters of the discipline. Even when discussing individual artists, like Florine Stettheimer or Berthe Morisot or Rosa Bonheur, it is not merely to validate their work…but rather, in reading them, and often reading them against the grain, to question the whole art-historical apparatus which contrived to "put them in their place"; in other words, to

reveal the structures and operations that tend to marginalize certain kinds of artistic production while centralizing others.

The role of ideology constantly appears as a motivating force in all such canon formation and has, as such, been a constant object of my critical attention, in the sense that such analysis "makes visible the invisible." Althusser's work on ideology was basic to this undertaking, but I have never been a consistent Althusserian. On the contrary, I have paid considerable attention to other ways of formulating the role of the ideological in the visual arts.

Or to put it another way: when I embarked on "Why Have There Been No Great Women Artists?" in 1970, there was no such thing as a feminist art history. Like all other forms of historical discourse, it had to be constructed. New materials had to be sought out, theoretical bases put in place, methodologies gradually developed. Since that time, feminist art history and criticism, and, more recently, gender studies, have become an important branch of the discipline. Perhaps more importantly, the feminist critique (and of course allied critiques including colonialist studies, queer theory, African-American studies, etc.) has entered into the mainstream discourse itself: often, it is true, perfunctorily, but in the work of the best scholars, as an integral part of a new, more theoretically grounded and socially and psychoanalytically contextualized historical practice.

Perhaps this makes it sound as though feminism is safely ensconced in the bosom of one of the most conservative of the intellectual disciplines. This is far from the case. There is still resistance to the more radical varieties of the feminist

critique in the visual arts, and its practitioners are accused of such sins as neglecting the issue of quality, destroying the canon, scanting the innately visual dimension of the artwork, and reducing art to the circumstances of its production—in other words, of undermining the ideological and, above all, esthetic biases of the discipline. All of this is to the good; feminist art history is there to make trouble, to call into question, to ruffle feathers in the patriarchal dovecotes. It should not be mistaken for just another variant of or supplement to mainstream art history. At its strongest, a feminist art history is a transgressive and anti-establishment practice meant to call many of the major precepts of the discipline into question.

I would like to end on this somewhat contentious note: at a time when certain patriarchal values are making a comeback, as they invariably do during periods of conflict and stress, women must be staunch in refusing their time-honored role as victims, or mere supporters, of men. It is time to rethink the bases of our position and strengthen them for the fight ahead. As a feminist, I fear this moment's overt reversion to the most blatant forms of patriarchy, a great moment for so-called real men to assert their sinister dominance over "others"—women, gays, the artistic or sensitive—the return of the barely repressed. Forgetting that "terrorists" operate under the very same sign of patriarchy (more blatantly of course), we find in the *New York Times*, under the rubric "Heavy Lifting Required: the Return of Manly Men," "The operative word is men. Brawny, heroic, manly men." On it goes: we need father figures—forget heroic women, of course. What of the murdered airline hostesses—were they feisty heroines

or just "victims," patriarchy's favorite position for women? Although the female writer of the article admits that "part of understanding terrorism…often involves getting to the root of what is masculine," and that "the dark side of manliness has been on abundant display as information about the lives of the hijackers, as well as Osama bin Laden himself comes to light, revealing a society in which manhood is equated with violent conquest and women have been ruthlessly prevented from participating in almost every aspect of life," and, in quoting Gloria Steinem, contends that "the common thread in violent societies is the polarization of sex roles," and even though the *Times* felt uncomfortable enough about "The Return of Manly Men" to append at its base an article, "Not to Worry: Real Men Can Cry," the implications of the piece ring out loud and clear.[11] Real men are the good guys; the rest of us are wimps and whiners—read "womanish."

In a similar but more specifically art-oriented vein, a recent *New Yorker* profile of departing MoMA curator Kirk Varnedoe brings the call for the return of manly men directly into the art world—Varnedoe is described as "handsome, dynamic, fiercely intelligent and dauntingly articulate."[12] He made himself into a football player. At Williams College, whose art history department would shortly become famous as an incubator of American museum directors, he found that what his remarkable teachers, S Lane Faison, Whitney Stoddard, and William Pierson, did "in the first place, was to take the curse of effeminacy off art history."[13] Stoddard went to all the hockey games and came to class on skis in the winter—a sure anti-feminine qualification in an art historian.

At the Institute of Fine Arts, "legions of female students fell in love with him. One of them wrote him a love letter in lieu of an exam paper."[14]

Of course, this description is over the top in its advocacy of masculine dominance in the art world. It is not, alas, totally exceptional. Every time I see an all-male art panel talking "at" a mostly female audience, I realize there is still a way to go before true equality is achieved. But I think this is a critical moment for feminism and women's place in the art world. Now, more than ever, we need to be aware not only of our achievements but of the dangers and difficulties lying in the future. We will need all our wit and courage to make sure that women's voices are heard, their work seen and written about. That is our task for the future.

Notes

Why Have There Been
No Great Women Artists?

1 Kate Millett's (1970) *Sexual Politics*,
Garden City, NY: Doubleday & Co,
Inc., and Mary Ellmann's (1968),
Thinking about Women, New York,
NY: Harcourt Brace Jovanovich, Inc.,
provide notable exceptions.

2 "Women Artists" (1858), review of
Die Frauen in die Kunstgeschichte by
Ernst Guhl in *The Westminster Review*
(American Edition), LXX, July,
pp. 91–104. I am grateful to Elaine
Showalter for having brought this
review to my attention.

3 See, for example, Peter S Walch's
excellent studies of Angelica Kauffmann,
or his unpublished doctoral dissertation,
"Angelica Kauffmann" (1968), Princeton,
NJ, on the subject; for Artemisia
Gentileschi, see R Ward Bissell (1968),
"Artemisia Gentileschi—A New
Documented Chronology," *Art
Bulletin*, L (June), pp. 153–68.

4 Ellmann, *Thinking about Women*.

5 John Stuart Mill (1966), "The
Subjection of Women" (1869), in *Three
Essays by John Stuart Mill*, London:
Oxford University Press, p. 441.

6 For the relatively recent genesis of the
emphasis on the artist as the nexus of
esthetic experience, see MH Abrams
(1953), *The Mirror and the Lamp:*

*Romantic Theory and the Critical
Tradition*, New York: WW Norton,
and Maurice Z Shroder (1961), *Icarus:
The Image of the Artist in French
Romanticism*, Cambridge, MA: Harvard
University Press.

7 A comparison with the parallel myth
for women, the Cinderella story, is
revealing: Cinderella gains higher status
on the basis of a passive, "sex-object"
attribute—small feet—whereas the Boy
Wonder always proves himself through
active accomplishment. For a thorough
study of myths about artists, see Ernst
Kris and Otto Kurz (1934), *Die Legende
vom Künstler: Ein geschichtlicher Versuch*,
Vienna: Krystall Verlag.

8 Nikolaus Pevsner (1940), *Academies
of Art, Past and Present*, Cambridge:
Cambridge University Press, p. 96f.

9 Contemporary directions—earthworks,
conceptual art, art as information, etc.—
certainly point *away* from emphasis
on the individual genius and saleable
products; in art history, Harrison C
and Cynthia A White's (1965) *Canvases
and Careers: Institutional Change in
the French Painting World*, New York:
John Wiley & Sons, opens up a fruitful
new direction of investigation, as did
Nikolaus Pevsner's pioneering *Academies
of Art*. Ernst Gombrich and Pierre
Francastel, in their very different ways,
always have tended to view art, and the
artist, as part of a total situation rather
than in lofty isolation.

10 Female models were introduced in the
 life class in Berlin in 1875, in Stockholm
 in 1839, in Naples in 1870, at the Royal
 College of Art in London after 1875
 (Pevsner, *Academies of Art*, p. 231). Female
 models at the Pennsylvania Academy of
 the Fine Arts wore masks to hide their
 identity as late as about 1866—as attested
 to in a charcoal drawing by Thomas
 Eakins—if not later.

11 Pevsner, *Academies of Art*, p. 231.

12 White, *Canvases and Careers*, p. 51.

13 White, *Canvases and Careers*, Table 5.

14 Sarah Stickney Ellis (1844), *The
 Daughters of England: Their Position in
 Society, Character, and Responsibilities*
 (1842), in *The Family Monitor*, New
 York: HG Langley, p. 35.

15 Ellis, *The Family Monitor*, pp. 38–39.

16 Patricia Thomson (1956), *The Victorian
 Heroine: A Changing Ideal*, London:
 Oxford University Press, p. 77.

17 White, *Canvases and Careers*, p. 91.

18 Anna Klumpke (1908), *Rosa Bonheur:
 sa vie son oeuvre*, Paris: E Flammarion,
 p. 311.

19 Betty Friedan (1963), *The Feminine
 Mystique*, New York: WW Norton,
 p. 158.

20 Klumpke, *Rosa Bonheur*, p. 166.

21 Like many cities even today, there
 were areas that had laws against
 impersonation.

22 Klumpke, *Rosa Bonheur*, pp. 308–9.

23 Klumpke, *Rosa Bonheur*, pp. 310–11.

24 Cited in Elizabeth Fisher (1970),
 "The Woman as Artist. Louise
 Nevelson," *Aphra*, I, Spring, p. 32.

"Why Have There Been No Great
Women Artists?" Thirty Years After

1 *ARTnews* 68, March 1969–February 1970.

2 *ARTnews* 69, March 1970–February 1971.

3 Vivian Gornick and Barbara Moran,
 ed. (1971), *Women in Sexist Society*,
 New York, NY: Balk Books.

4 *ARTnews* 69, January 1971.

5 Louis Menand (2001), *New Yorker*,
 October 15, p. 203.

6 Menand (2001), *New Yorker*, October 15,
 p. 210.

7 Alex Potts (1999), "Louise Bourgeois—
 Sculptural Confrontations," *Oxford Art
 Journal*, 22, no. 2, p. 37.

8 *New York Review of Books*, November 20,
 2000, p. 33.

9 *Artforum*, November 2001, p. 143.

10 *Artforum*, November 2001, p. 143.

11 *New York Times*, October 28, 2001,
 section 4, p. 5.

12 *New Yorker*, November 5, 2001, p. 72.

13 *New Yorker*, November 5, 2001, p. 76.

14 *New Yorker*, November 5, 2001, p. 78.

Further Reading

By Linda Nochlin

D'Souza, Aruna ed., *Making It Modern: A Linda Nochlin Reader*, New York: Thames & Hudson, forthcoming

Harris, Ann Sutherland, and Linda Nochlin, *Women Artists, 1550–1950*, Los Angeles: Los Angeles County Museum of Art, 1976

Nochlin, Linda, and Tamar Garb, eds., *Jew in the Text: Modernity and the Construction of Identity*, London: Thames & Hudson, 1995

Nochlin, Linda, *Representing Women*, New York: Thames & Hudson, 1999

Nochlin, Linda, W*omen, Art, and Power and Other Essays*, Boulder, Colorado: Westview, 1988

Reilly, Maura, and Linda Nochlin, eds., *Global Feminisms: New Directions in Contemporary Art*, London: Merrell, 2007

Reilly, Maura ed., *Women Artists: The Linda Nochlin Reader*, London: Thames & Hudson, 2015

About Linda Nochlin

D'Souza, Aruna, ed., *Self and History: A Tribute to Linda Nochlin*, London: Thames & Hudson, 2001

Garb, Tamar and Ewa Lajer-Burcharth, 'Remembering Linda Nochlin', *The Art Bulletin*, 99, no. 4 (2 October 2017), 7–9

Nixon, Mignon, 'Women, Art, and Power After Linda Nochlin', *October*, 163 (March 2018), 131–32

Recent publications on feminist art history

Armstrong, Carol M., and M. Catherine de Zegher, eds., *Women Artists at the Millennium*, Cambridge, Mass.: MIT Press, 2006

Butler, Cornelia H., and Lisa Gabrielle Mark, eds., *WACK!: Art and the Feminist Revolution*, Los Angeles: Museum of Contemporary Art, 2007

Horne, Victoria, and Lara Perry, eds., *Feminism and Art History Now: Radical Critiques of Theory and Practice*, London: I. B. Tauris, 2019

Jones, Amelia, ed., *The Feminism and Visual Culture Reader,* London; New York: Routledge, 2nd edition, 2010

Jones, Amelia, and Erin Silver, eds., *Otherwise: Imagining Queer Feminist Art Histories*, Manchester: Manchester University Press, 2016

Meskimmon, Marsha, *Transnational Feminisms, Transversal Politics and Art: Entanglements and Intersections*, London; New York: Routledge, 2020

Meskimmon, Marsha, and Dorothy Rowe, eds., *Women, the Arts and Globalization: Eccentric Experience*, Manchester: Manchester University Press, 2015

Morris, Catherine, ed., *We Wanted a Revolution: Black Radical Women, 1965–85: New Perspectives*, New York: Brooklyn Museum, 2018

Parker, Rozsika, and Griselda Pollock, *Old Mistresses: Women, Art and Ideology*, London: I.B.Tauris, 1981, 2nd edition, 2013

Pejic, Bojana, ed., *Gender Check: a Reader: Art and Gender in Eastern Europe since the 1960s*, Köln; London: Walther König, 2011

Pollock, Griselda, *Encounters in the Virtual Feminist Museum: Time, Space and the Archive*, London; New York: Routledge, 2007

Pollock, Griselda, ed., *Generations and Geographies in the Visual Arts: Feminist Readings*, London; New York: Routledge, 1996

Reckitt, Helena, ed., *Art and Feminism*, London; New York: Phaidon, 2001, 2nd edition, 2012

Robinson, Hilary, and Maria Elena Buszek, eds., *A Companion to Feminist Art*, Hoboken, New Jersey: Wiley Blackwell, 2019

Picture Credits

Frontispiece Metropolitan Museum
of Art, New York. Mr. and Mrs. Isaac
D. Fletcher Collection, Bequest of Isaac
D. Fletcher, 1917

8 Galleria degli Uffizi, Florence

20 Metropolitan Museum of Art,
New York. Bequest of Mrs.
Charles Wrightsman, 2019

25 Galleria degli Uffizi, Florence

29 Metropolitan Museum of Art,
New York. Bequest of Mrs.
Charles Wrightsman, 2019

45, 46–7 Royal Collection Trust, London

49, 50–1 Philadelphia Museum of Art.
Gift of Charles Bregler, 1977

59, 60–1 Tate, London

62 Musée des Beaux-Arts, Marseille

64, 66–7 Musée Marmottan, Paris

77, 78–9 Metropolitan Museum of Art,
New York. Gift of Cornelius Vanderbilt,
1887

88 Art Gallery of Ontario, Toronto.
Courtesy Pippy Houldsworth Gallery,
London. © Mary Kelly 2021

91 Photo © Werner Kaligofsky.
© Rachel Whiteread

92 Literaturhaus München. Photo
® Kay Blaschke

95 Yale University, New Haven. Photo
Norman McGrath. Courtesy Pace Gallery.
© Maya Lin Studio

97, 98–9 Museum of Modern Art,
New York/Scala, Florence. Courtesy
of Sikkema Jenkins & Co., New York.
© Kara Walker

Frontispiece: Marie Denise Villers, *Marie Joséphine Charlotte du Val d'Ognes*,
1801 (detail). Oil on canvas, 63½ × 50⅝ in. (161.3 × 128.6 cm)

First published in the United Kingdom in 2021 by
Thames & Hudson Ltd, 181A High Holborn, London wc1v 7qx

First published in the United States of America in 2021 by
Thames & Hudson Inc., 500 Fifth Avenue, New York, New York 10110

Reprinted 2022

Introduction by Catherine Grant

British Library Cataloguing-in-Publication Data
A catalogue record for this book is available from the British Library

Library of Congress Control Number 2020940727

ISBN 978-0-500-02384-6

Printed and bound in Slovenia by DZS-Grafik d.o.o.

MIX
Paper from
responsible sources
FSC® C106600
FSC
www.fsc.org